The Cloisters
of
Iona Abbey

Ewan Mathers was born in Northern Ireland, brought up in England, educated in Scotland and after teaching in America is currently living in England again. Over a fifteen year period he lived, worked and was married on the Isle of Iona. From birth he spent most of his holidays on Iona and returns regularly to the island.

In the past Ewan has published several of his photographs as cards and postcards, with some being used in other publications. *The Cloisters*, based on his personal obsession with these unique carvings, is his first book.

The
Cloisters
of
Iona Abbey

Ewan Mathers

WILD GOOSE PUBLICATIONS

First published 2001 by
Wild Goose Publications, Unit 16, Six Harmony Row,
Glasgow G51 3BA, UK,
the publishing division of the Iona Community.
Scottish Charity No. SCO03794.
Limited Company Reg. No. SCO96243.

website: www.ionabooks.com

ISBN 1 901557 60 X

Distributed in Australia by Willow Connection Pty Ltd, Unit 4A, 3-9 Kenneth Road,
Manly Vale, NSW 2093, Australia,
and in New Zealand by Pleroma Christian Supplies, Higginson St., Otane 4170,
Central Hawkes Bay, New Zealand.

Permission to reproduce any part of this work in Australia
or New Zealand should be sought from Willow Connection.

Design and typesetting by Wild Goose Publications
Produced by Reliance Production Company, Hong Kong
Printed and bound in China

Contents

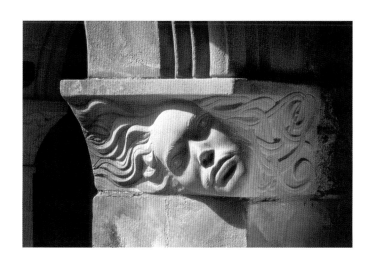

The Cloisters – An Introduction

When I first came to Iona as a baby, the cloisters were also new. As I grew up, so did they: transformed from rough pillars of fragile sandstone into a complete, cyclical, unified work of art by over thirty years of careful attention. Each year that I returned to the island I would go back to the cloisters to see what new images had emerged from the bare stone blocks. Some years there would be two or three new carvings to marvel at; other years perhaps just one. Sometimes a whole side had been completed and another corner turned. Occasionally I would see the carver at work, covered in dust, gently removing stone to reveal a new inspiration. It was this early exposure to the cloisters that led to my wanting to reveal their beauty in words and pictures.

Since that time I have been lucky enough to live and work on Iona for a number of years and build on those early experiences. Around ten years ago I began looking more closely at the carvings and wanted to know more about them and what they represented. I also began to photograph them systematically. It seemed to me that many people walked past each day without noticing that all the carvings were different and certainly not knowing what they all were or why they were there. This eventually led me to meet Chris Hall, the principal carver. It was he whom I had watched for all these years. Since that time I have learnt what each of the carvings represents and a little about the history of them. I also began to understand that there is much more to this work at a deeper level, which I have tried to bring out in this book.

Cloisters form an environment in which to be and in which to think. I believe that their original purpose was both physical and spiritual. Firstly they provide a practical covered pathway linking the various parts of a monastic building; secondly they provide space for meditation, contemplation and silence. This

arrangement reflects the twofold nature of life in a monastery of daily work and worship; a theme explored today by the Iona Community, who now occupy the Abbey buildings on Iona.

The idea to re-create the cloisters using symbols from the natural world perhaps reflects the close links that the early Celtic Christian church had with the land around them. This understanding for things natural is evident in the artworks of the time, most notably the Book of Kells. Although the representations of plants and animals there are not strictly 'realistic', clearly the immediate environment was studied closely and revered. We now have the opportunity to regain this reverence for our local surroundings along with the myths and legends that go with it.

Finding places that we feel comfortable in can be difficult these days. There seem to be so many distractions, it can be hard to keep our minds focused on one thing. Spending any time on ourselves, and our personal needs, becomes a daily task: one that has to be thought of consciously. The need for places of quiet reflection is no less now than when these cloisters were first built.

In ancient mythology there exists the idea of the labyrinth. These pathways were used as celebrations of life and death as well as places of meditation. The classical seven-circuit labyrinth, which occurs throughout time and place in history, is unicursal (one pathway) in form. Its winding circular path leads the walker to a central place and then out again. The purpose was not to reach any physical point but rather to effect a change in the walker's awareness. This theme is seen in the Celtic knotwork patterns. Here the eye is guided on an eternal pathway, always coming back to the beginning. In more recent times the labyrinths were reinterpreted as simple mazes for amusement, their deeper relevance lost.

Cloisters can be seen as single-circuit, unicursal labyrinths following on this ancient tradition. They therefore can effect changes in consciousness if we allow

them the time and are aware of the possibilities. On this pathway there is no sense of being lost; you will always be returned to where you began. In this sense it is a safe environment in which to explore the deeper aspects of our existence. The certainties of such pathways bring us peace through their constancy.

I feel that the direction of travel around the Iona cloisters should be sunwise, beginning and ending at the south-east corner, 'Alpha and Omega'; one circuit representing one day. Our daily journey then begins at sunrise, with plants from the eastern 'Holy Land'. We then move through midday, symbolised by the flight of birds overhead. The western setting sun brings us closer to home with the British flora, and finally we return to Iona at nightfall.

It is also possible to reflect the yearly seasons in such a journey:

East	=	spiritual renewal	=	Spring
South	=	time for expansion	=	Summer
West	=	maturing of ideas	=	Autumn
North	=	nurturing at home	=	Winter

Each day and each year brings us back to a point where the cycle begins again. Although we return to the same physical place where we began, we are changed by this process.

These particular cloisters on Iona are unusual in that the carvings on the capital heads are all different. It is far more common for capital heads to be all the same. The two medieval carvings that remain, from the 13th century, are of different plants and so inspired the new carvings to follow on from their example. These new carvings have taken thirty years to complete. In an age when speed is seen to be desirable it is heartening to witness such long-term commitment to a task. My contribution, set out here, has not taken nearly as long. For a more detailed account of the background to the carvings and the poem please refer to the appendix.

Each of the carvings has its story, each has its place, but they present their own collective puzzle: how to see the complete work? It requires the viewer to follow in the footsteps of those who first trod the pathway in quiet moments in the past. This is a hidden work. You are always aware of the other columns and carvings; and yet no more than two sides ever reveal themselves. It is truly an interactive sculpture requiring the participation of the viewer.

Perhaps the greatest achievement in the carving of the cloister capitals is the space that they leave behind through which we are invited to travel. What is left for us to enjoy is a reflection of all the stone that has been removed.

Once you embark on this path you are no longer passive but must engage in active thought and motion. A meditative walk around the cloisters returns us to the same physical point but our spirit has undergone a change.

I invite you now to begin that journey.

Ewan, 2001

Acknowledgements

In the preparation of this work there are many whom I would like to thank.

Firstly I must thank the principal carver of these cloisters, Chris Hall. He gave me the inspiration to go forward with my ideas and produce this work, encouraging me to write about my own personal response to these wonderful carvings. Chris also spoke to me on many occasions, allowing me to tape his thoughts about the carvings, clarifying the identity of each one for the first time.

There are many others who also encouraged me with this project: Tess, Harry and Gwen for all their love, Cara Riley for her inspired suggestion, Tony Phelan and Jane Riley of the Iona Community and Wild Goose Publications for listening to the suggestion, Chris Calvert of Historic Scotland, Avril Grey of the Scottish Cultural Press, Patrick MacManaway and friends for labyrinthine help, Patricia MacManaway for Sligneach and healing, Sue Barnet (who once told me I have three books in me!), everyone with whom I have worked over the years at Iona Abbey and the Argyll Hotel (especially Fiona Menzies) and all my friends both on and off Iona and, of course, the Isle of Iona itself.

The Cloisters

Alpha and Omega

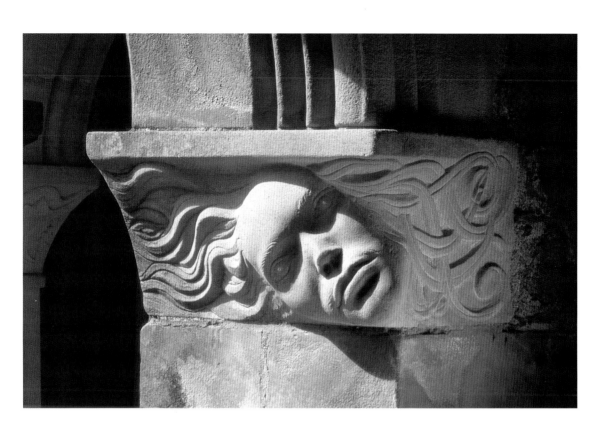

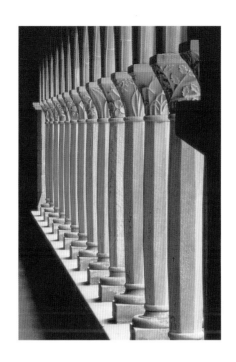

East

Let the red crown, blood soaked, thread
Mark out this royal pathway straight ahead.

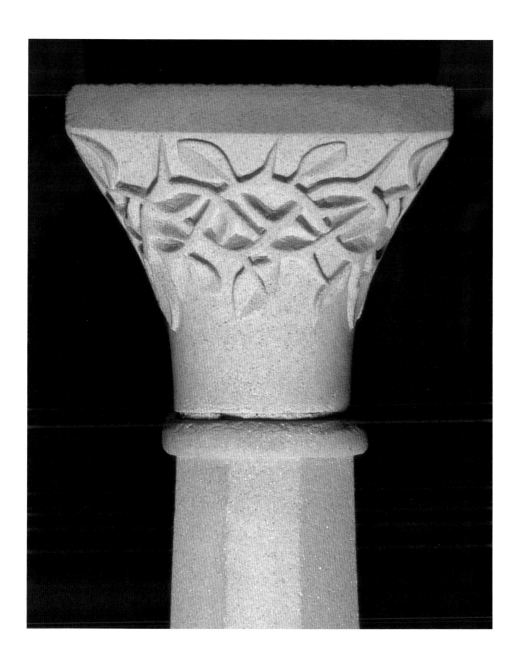

Thorns

Go, worship in the shade of these tall groves,
Most ancient hosts for all our thoughts,

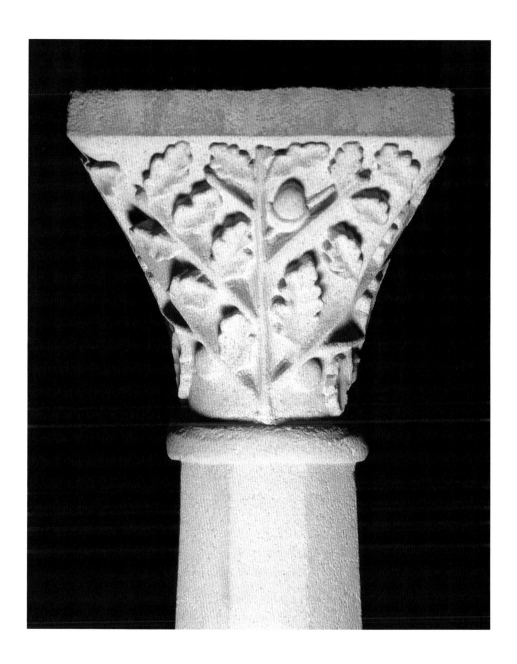

Oak

Here, deep within, live poisoned growths,
That time turns black to harm us.

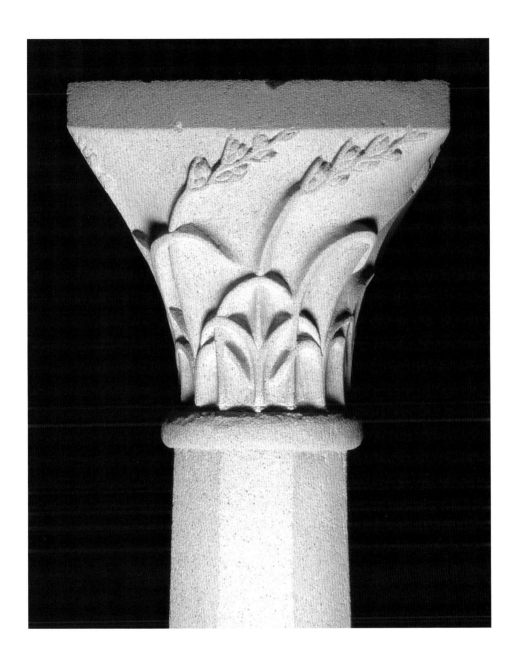

Darnel

And how our image is bright reflected,
So clearly, that we think we see it.

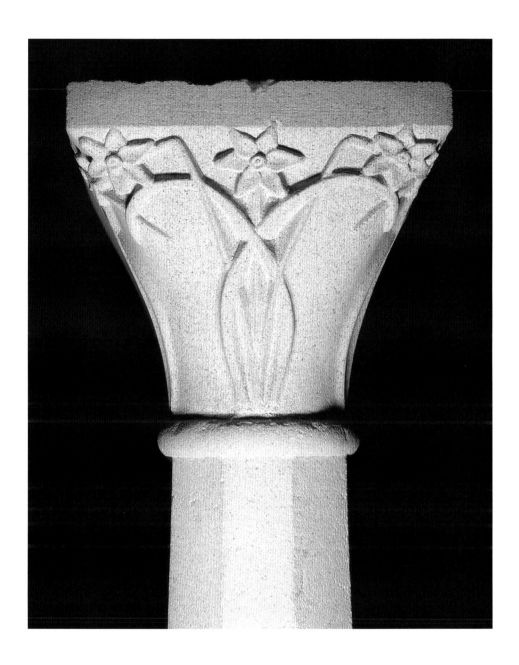

Narcissus

So circle, humbly, this endless pathway,
In eternal, constant, ringing motions:

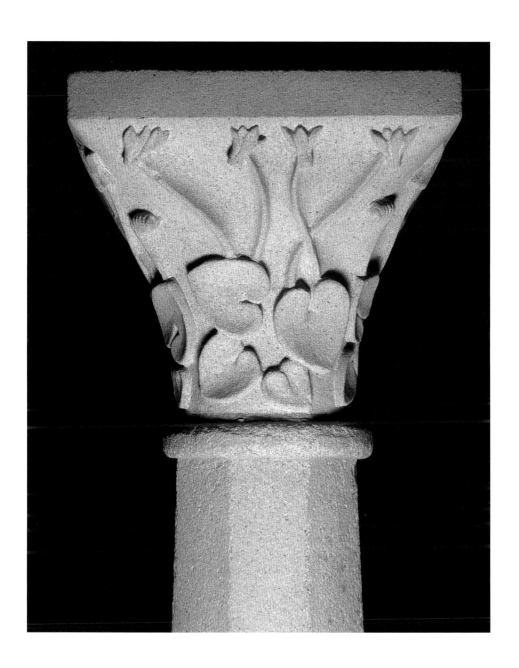

Cyclamen

And be saved from drowning rivers
That wash over your ambitions.

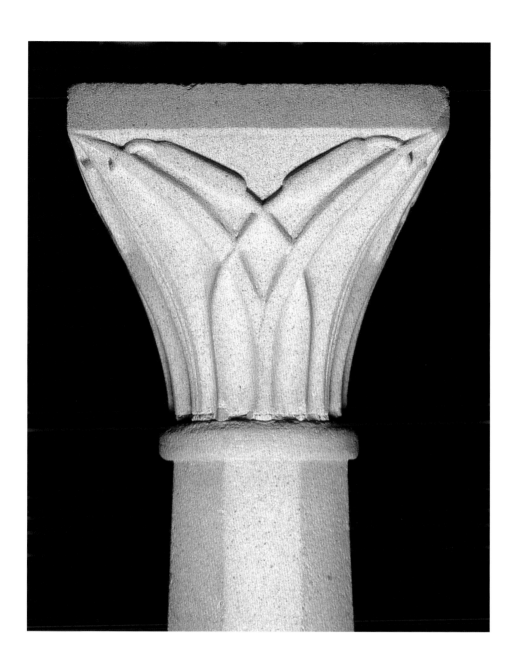

Bulrushes

Drink deep instead of finer wines;
Of life, and love, and happiness.

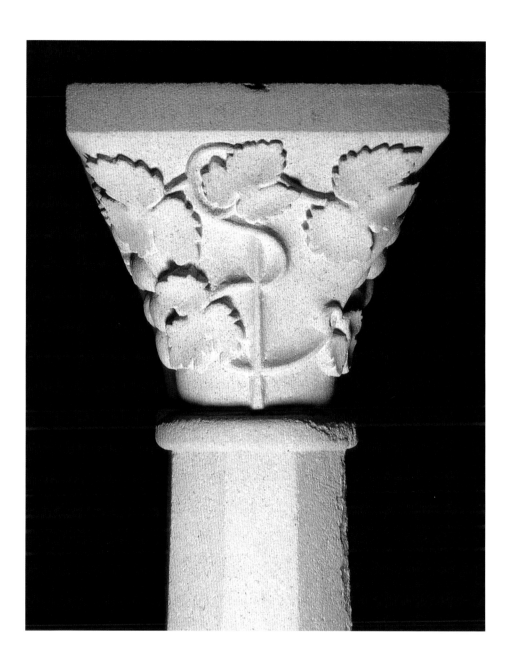

Vine

Eat too your daily risen staple:

For strength of body needs enriching.

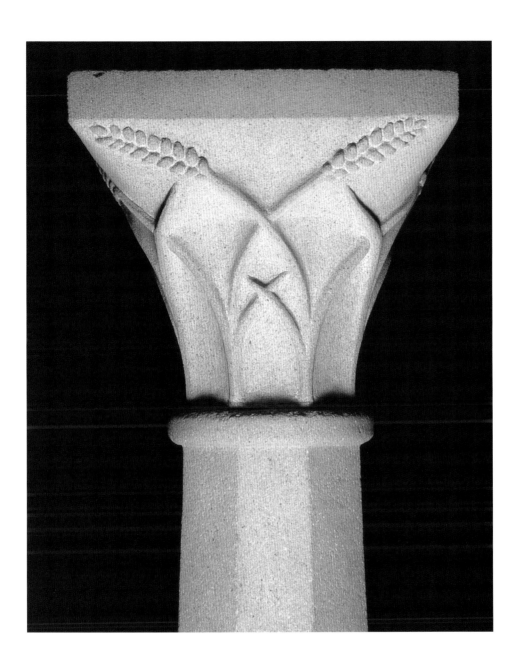

Wheat

Let differences and misunderstandings
Lead to laughter, smiles and joy.

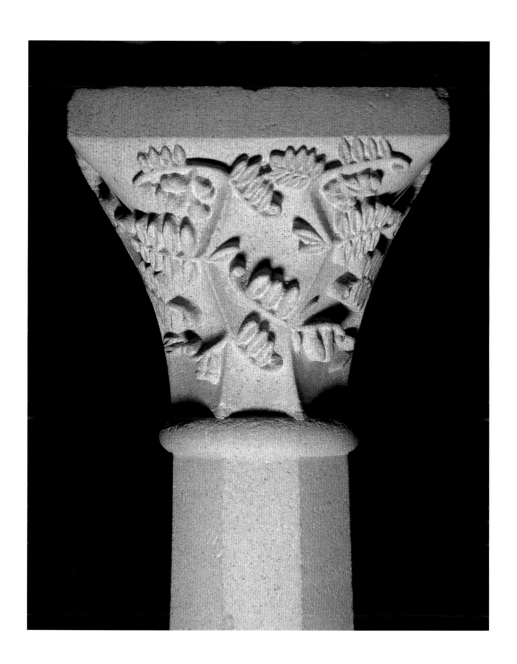

Vetch

Your outstretched hands in triumph raise
A victorious cry of upright grace.

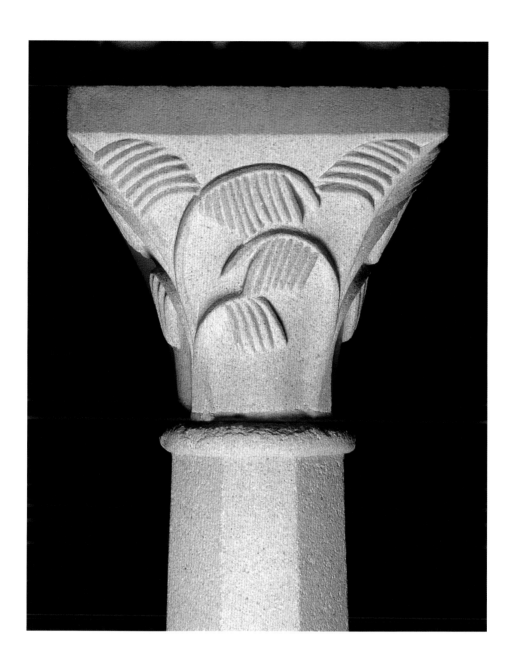

Palm

Warmed by the everlasting flame, that springs
Alive; transcending all belief.

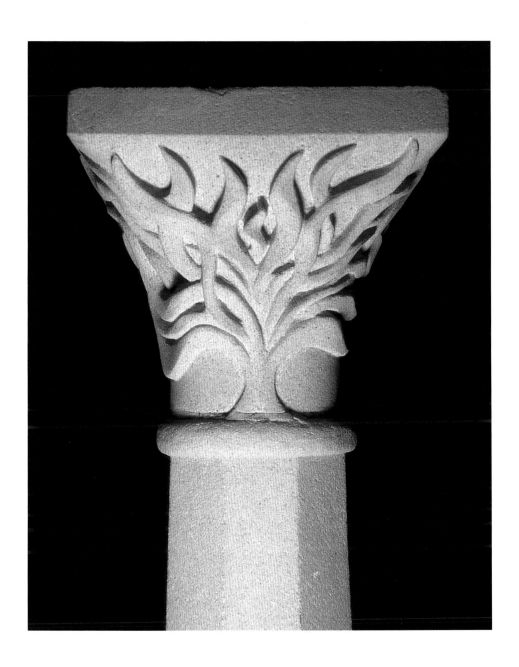

The Burning Bush

Pause: anoint your feet with reverence

For carrying you on your way.

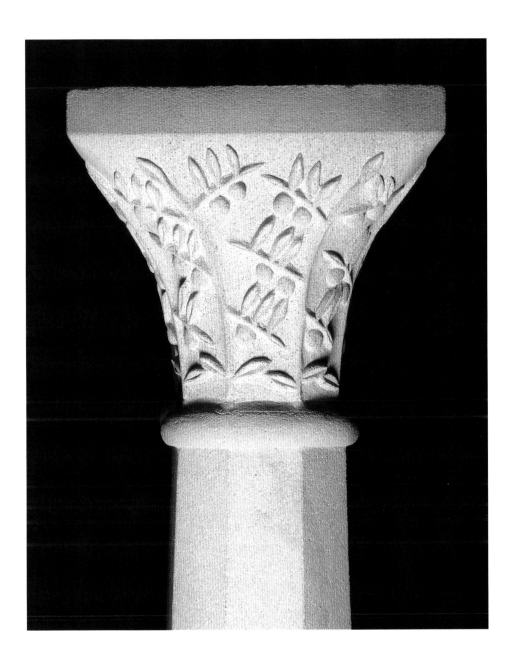

Olive

Of sensuality and prosperity;
Be moved to feast on these.

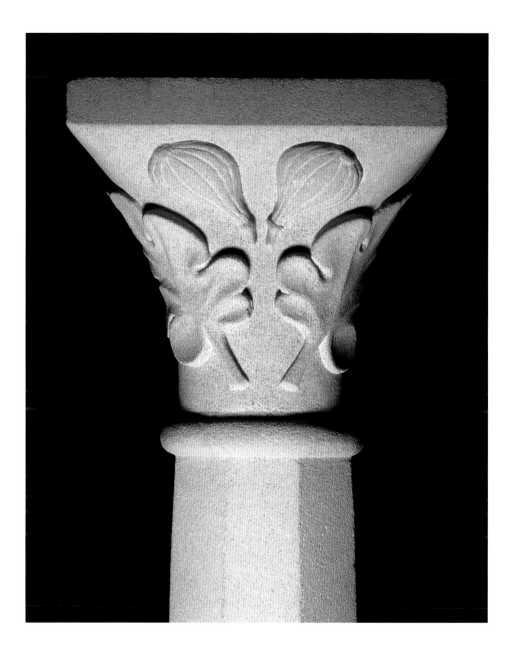

Fig

The windflower blows the soul's breath
And beauty bears a white star in death.

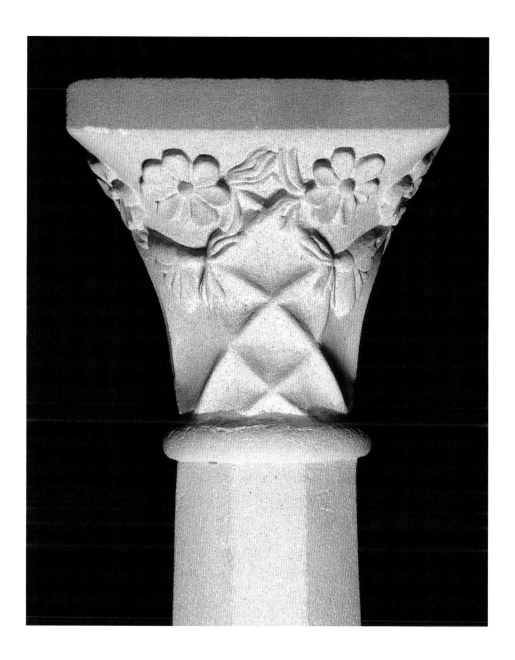

Anemone

Baptism

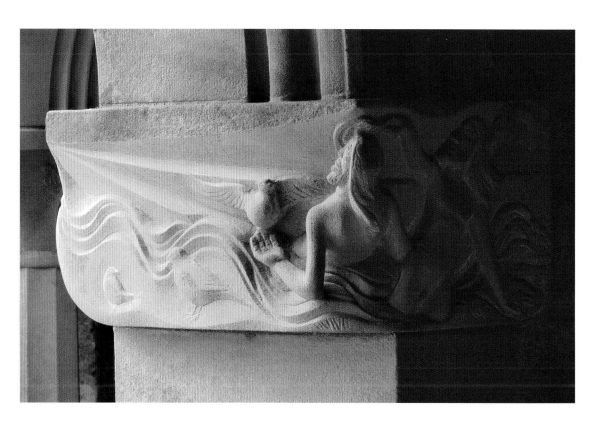

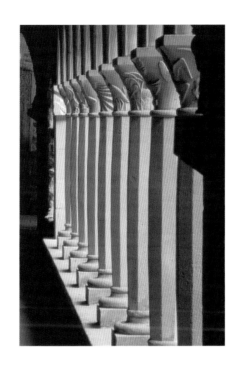

South

As Old Solan falls, with wings snap shut,

To pierce the waves in search of life,

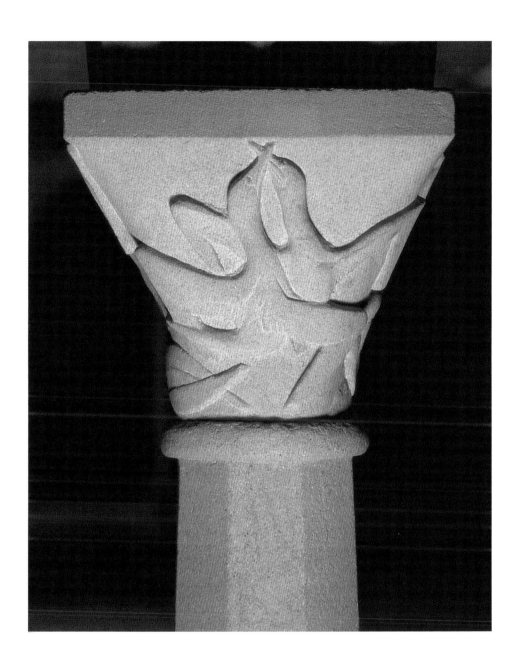

Gannet

Use your claws to cling to hope,
And live your life close by the edge.

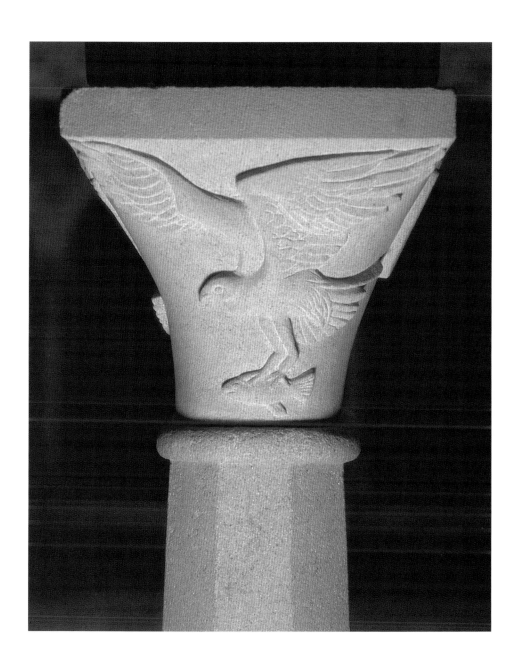

Osprey

Escape these green curtains, drawn in cover,
Sound out your drums and beat in time.

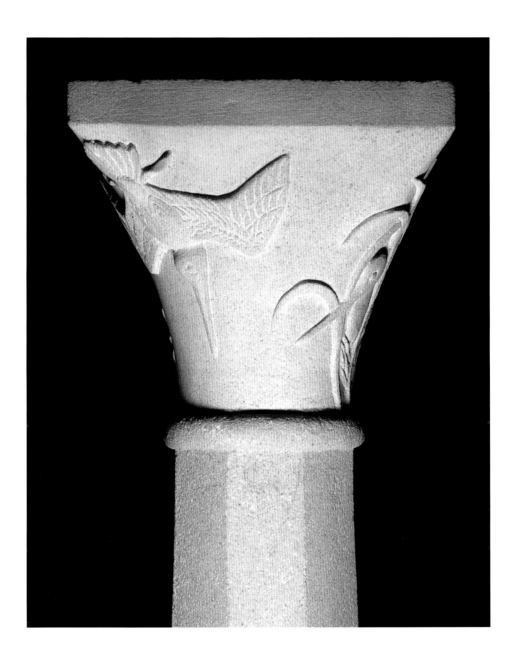

Snipe

Rise up and then glide gracefully down;
Stand firm, head crowned. Above all else:

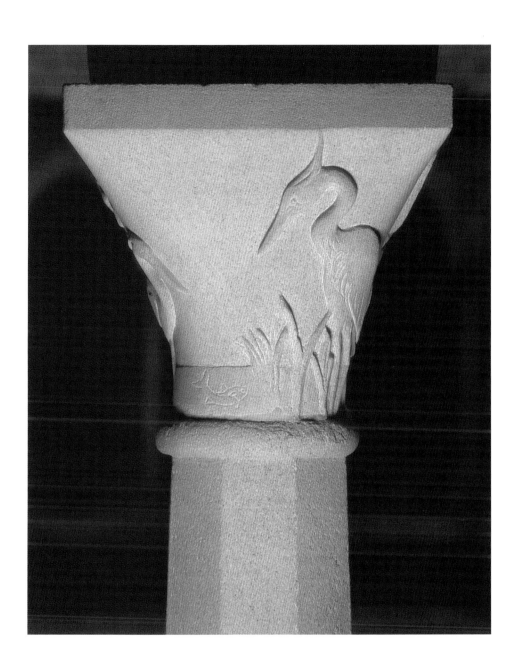

Heron

Embrace creation's central power of light,
Whose peace shall beam beyond us.

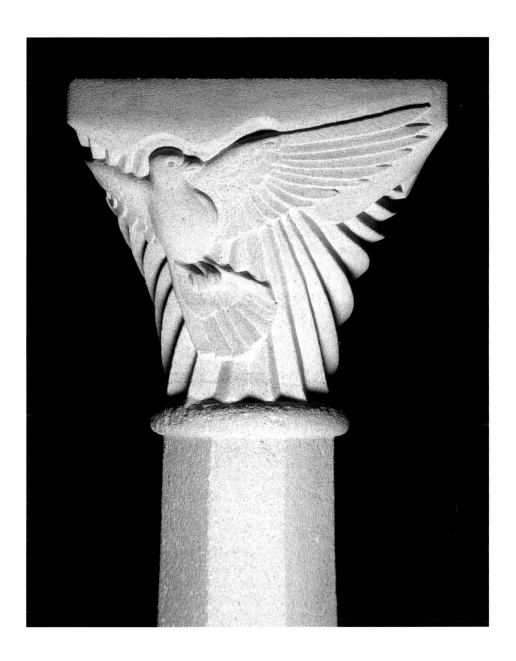

Dove

Cast forth your Art, that all might see
How simply you take on your fate.

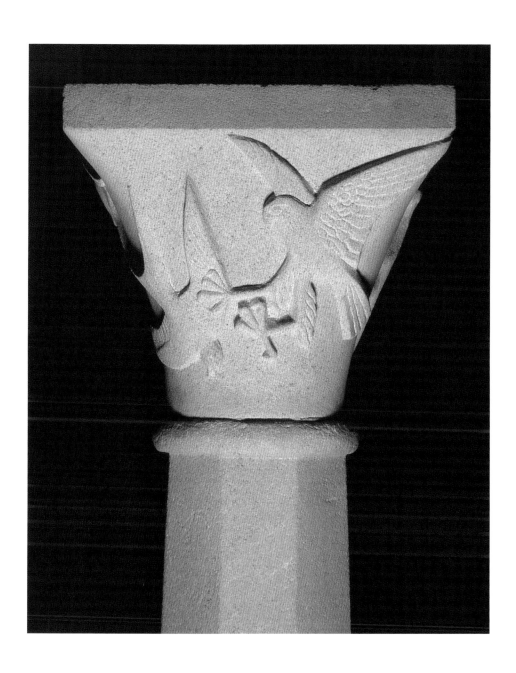

Merlin and Swallow

See how in one, so black and white,

The rarest and the greatest meet.

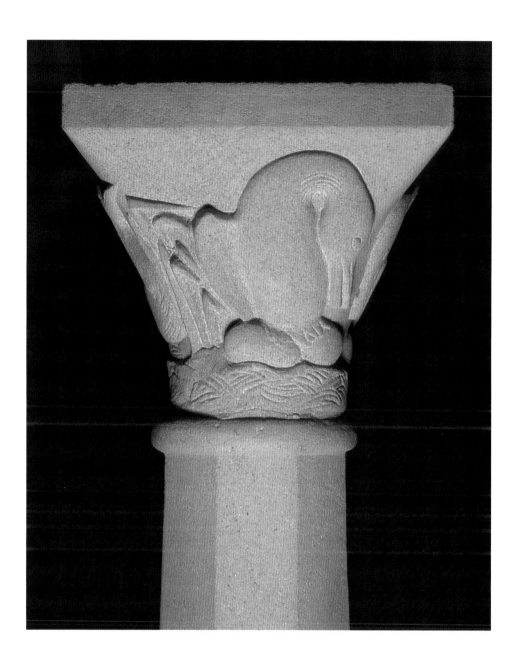

Great Northern Diver

Yet rarer still, our will to speak,
And overcome the silences.

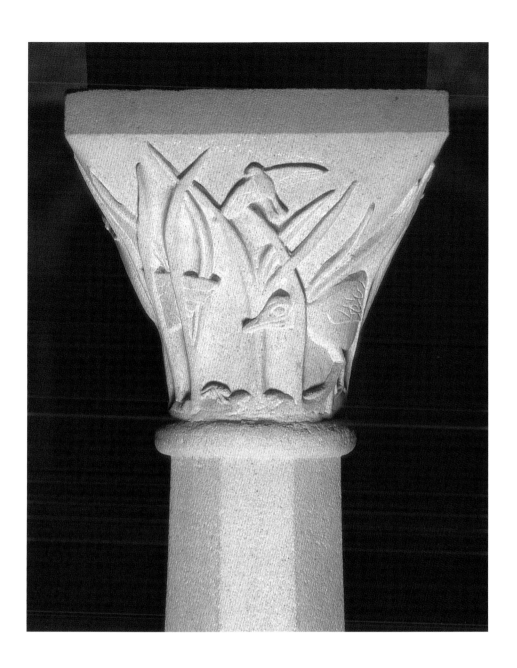

Corncrake

Look back along the sky's high edge,
Where light abides, as this day ebbs.

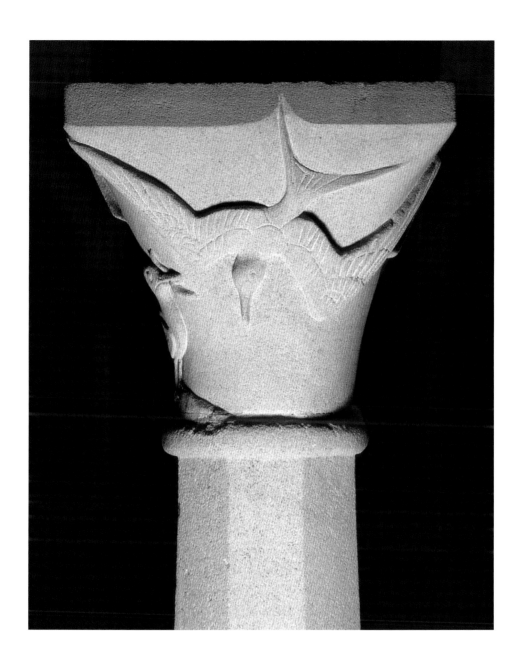

Tern

Raising of Lazarus

Nativity

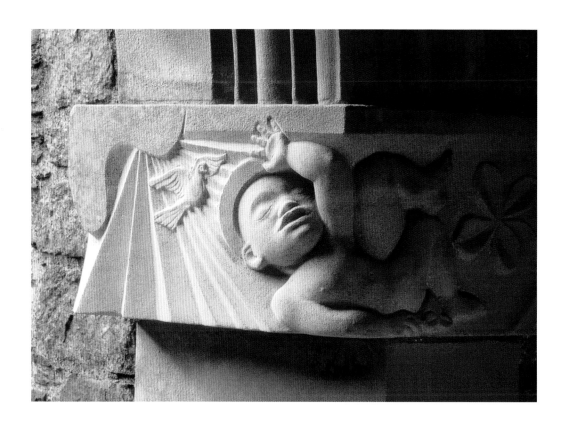

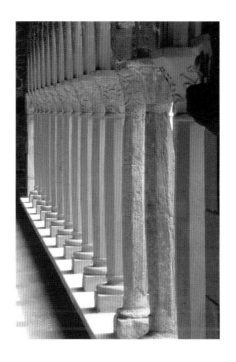

West

When evening comes, and autumn falls,
The twilight world of sprites unfolds.

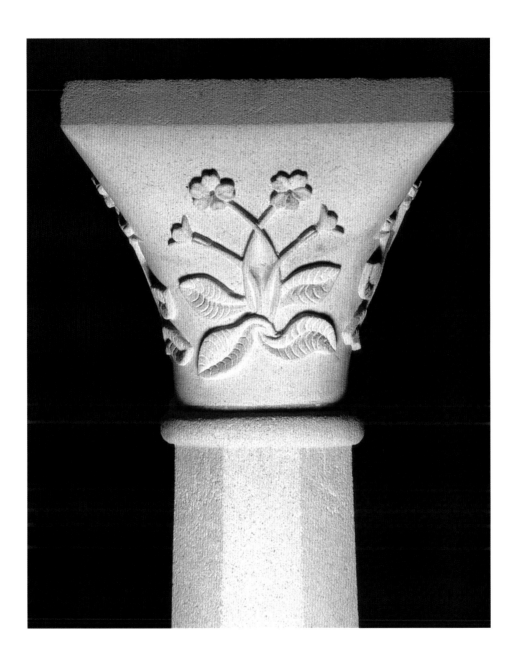

Primrose

Old mysteries now revealed as true,

The legends of our elders' age

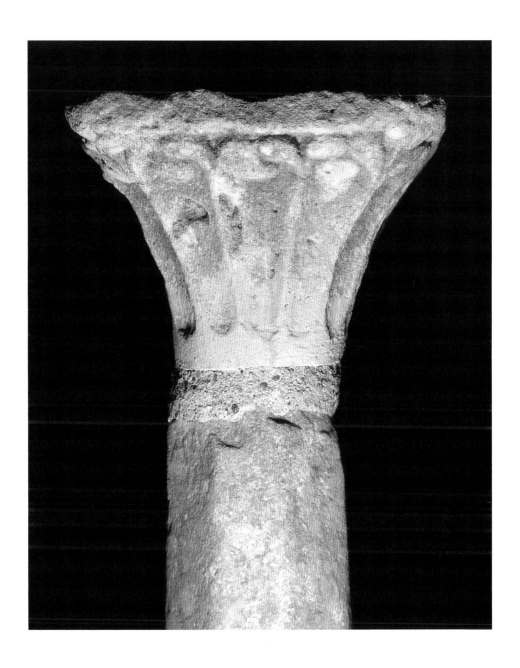

Medieval 1

Inspired creation of this space;

Through which we pass in awe.

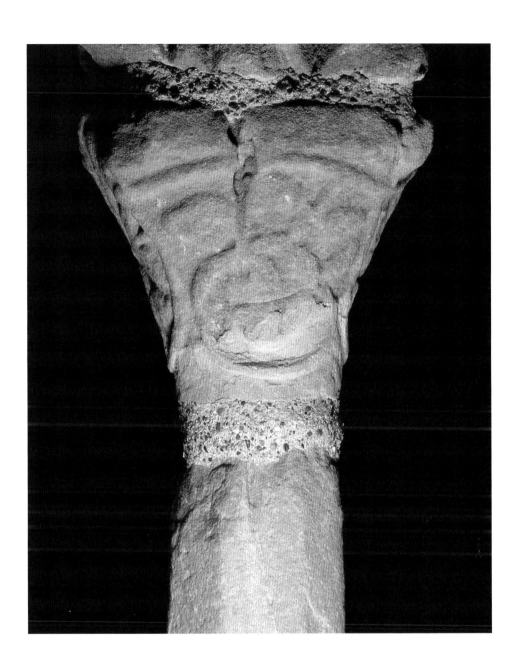

Medieval 2

Pressed close to rocks, to lie in rest,
Gaze on points of simple beauty.

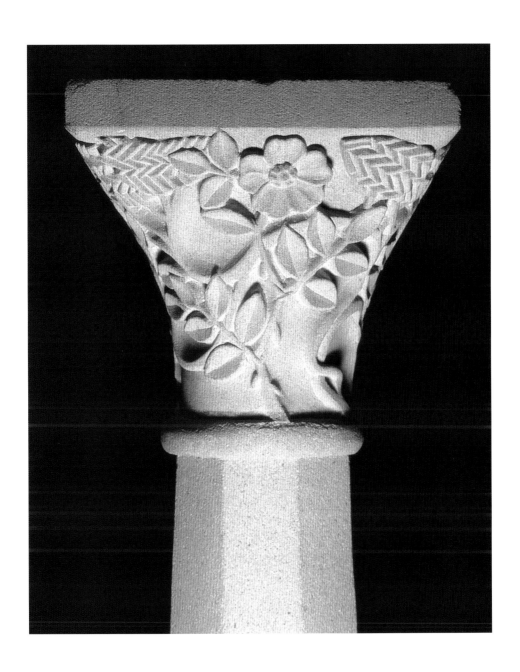

Dog Rose and Heather

In death; life's purpose understood.

As fragrance from these leaves evokes

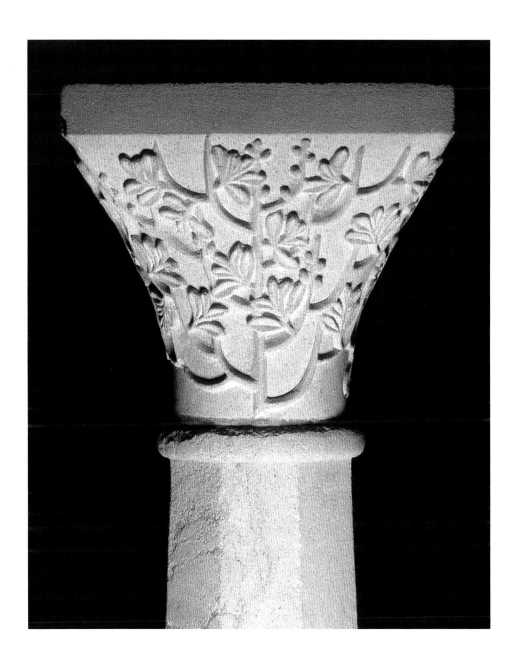

Bog Myrtle

A time of darkness and new light:

When hope is born to rise again.

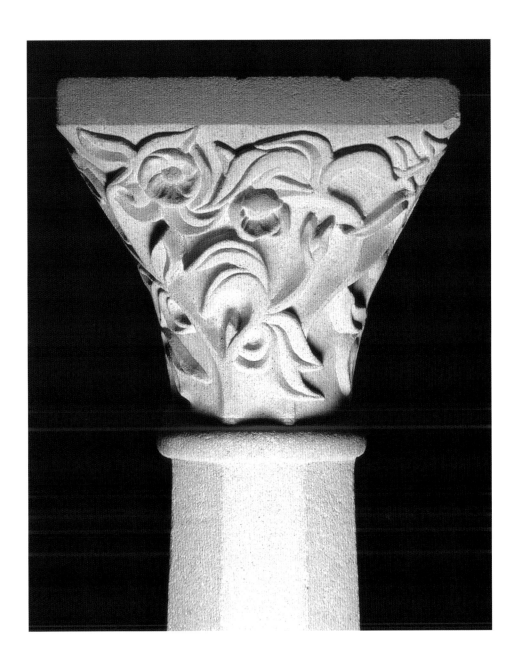

Christmas Rose

Scents so strong they carry you
Away beyond your present place.

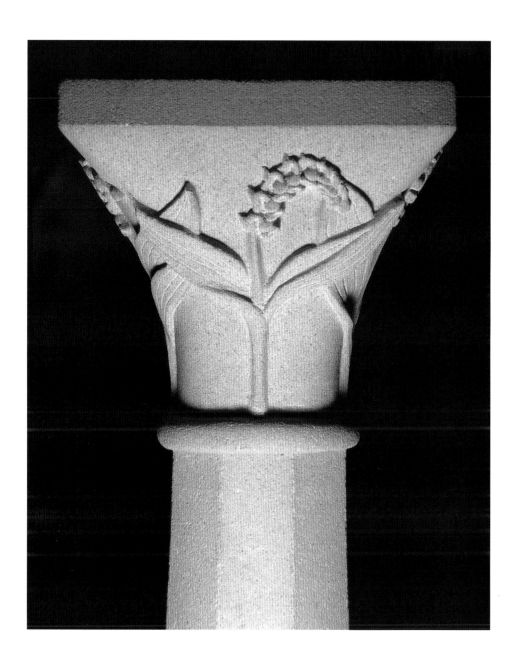

Lily of the Valley

Thoughts from youth fill up your mind,
With pure wonder at just knowing

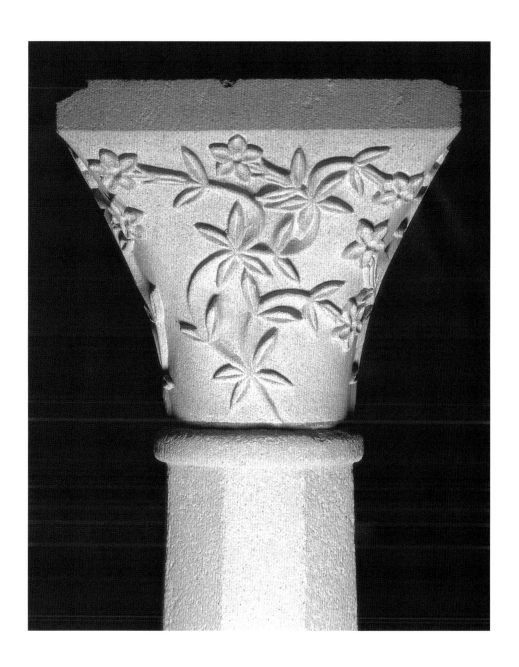

Spring Gentian

How spring unfolds, each year, to meet us,
Rainbows bring the end of storms.

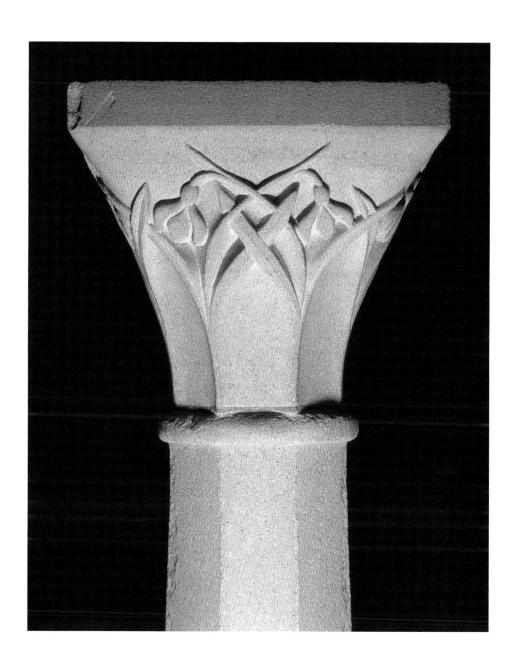

Snowdrop

Step lightly on these pads of gold;
Threefold holders of delight.

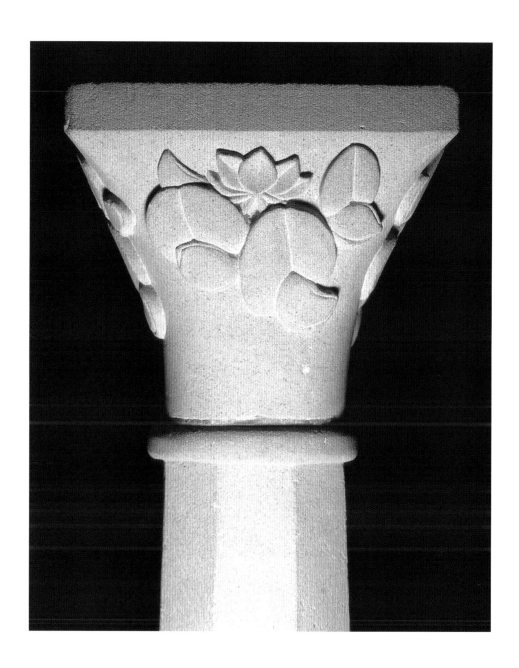

Birdsfoot Trefoil

Draw on your stock of former lives;
Raw essence of your own rebirth.

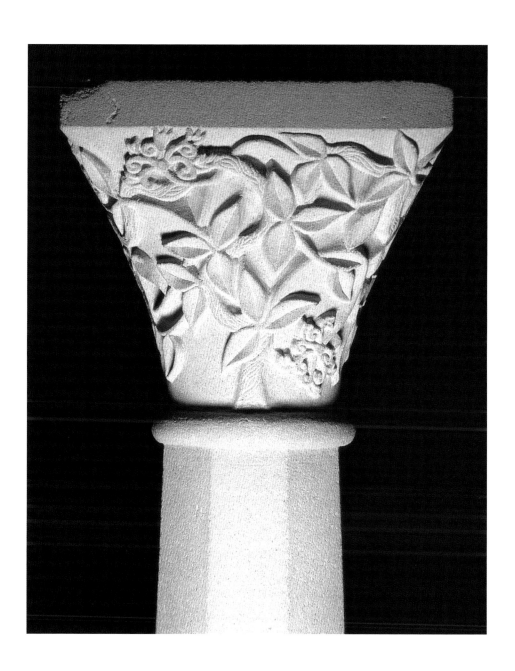

Honeysuckle

Choose carefully the route you take,
Avoid the traps that can deceive.

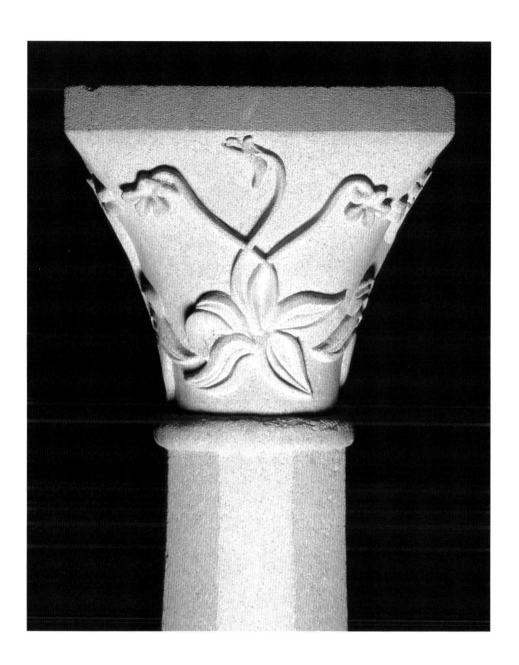

Butterwort

But our in-spiral journey does not confuse;
The goal is both the start and end.

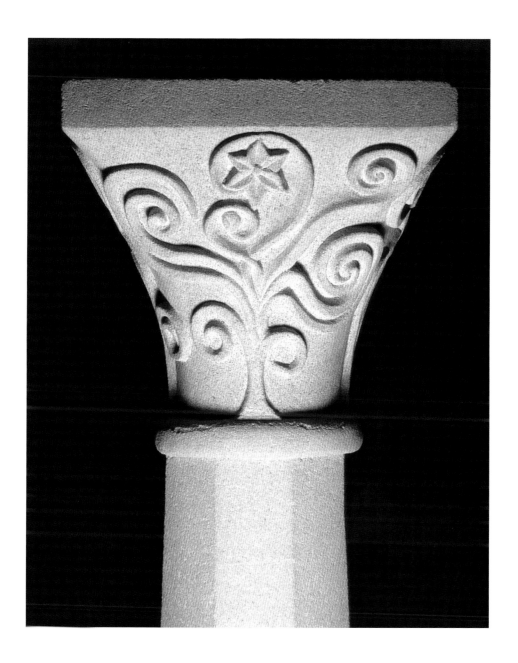

Warren Crocus

No danger here of sticking fast
Where others have before us failed.

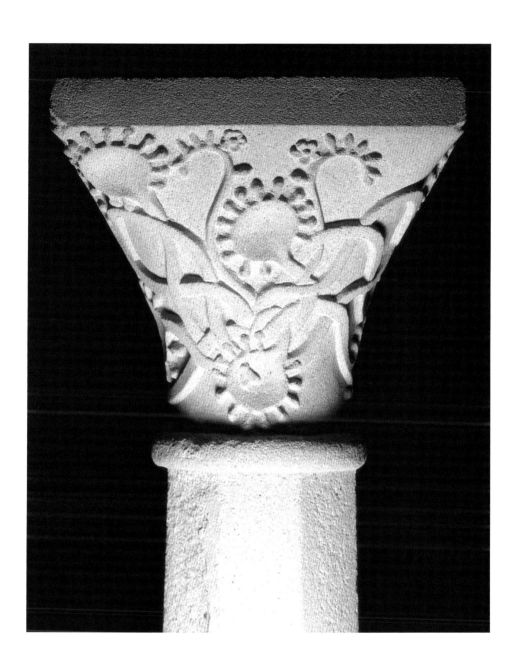

Sundew

Breaking of Bread

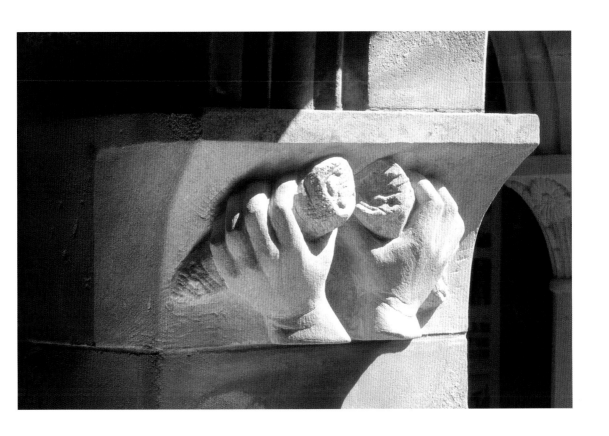

Offering of Wine

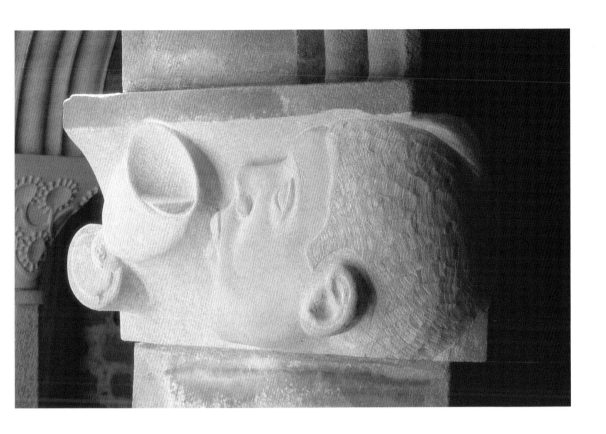

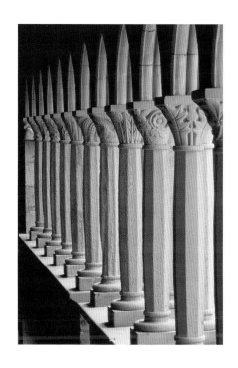

North

Nightfall: time of dreams and passions,
Full moon's eye stares into our soul.

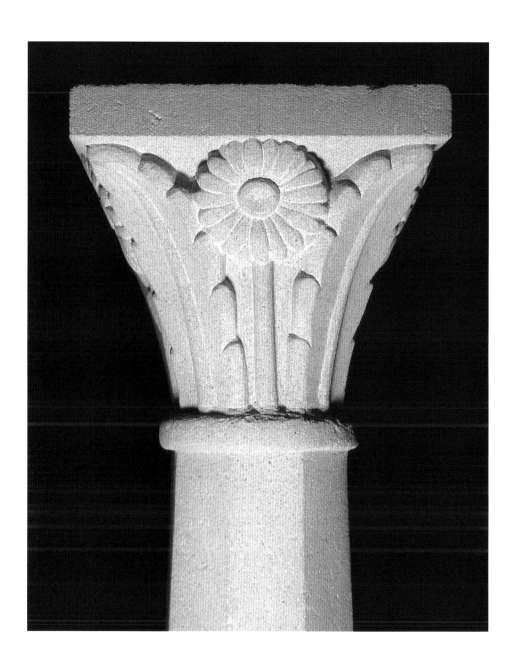

Marguerite

Now that each step is lit by stars
Echoes of memories, held on to, fade

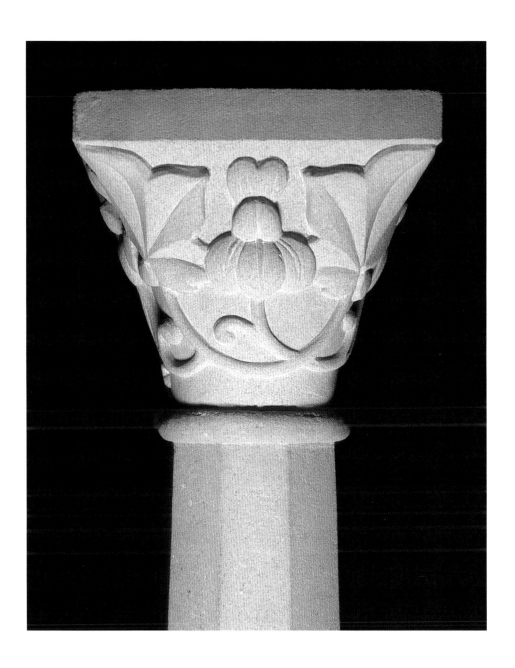

Ivyleaf Toadflax

But pricked, we do recall a time

When those attacked were timely saved

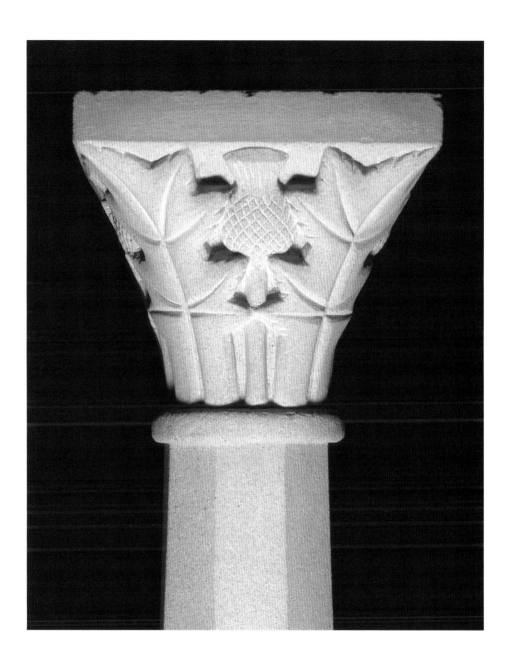

Thistle

To drink sweet liquor here distilled

From fruits of one year's blazing sun.

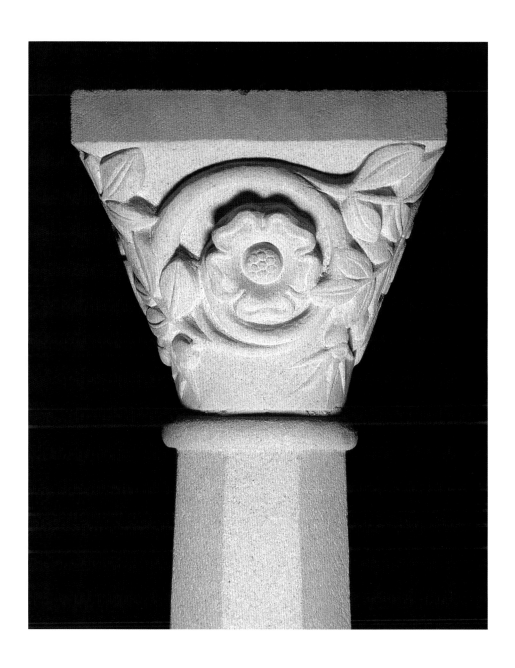

Scottish Rose

Roar as you eat, and count the time
Spent seeking; hoping soon to find

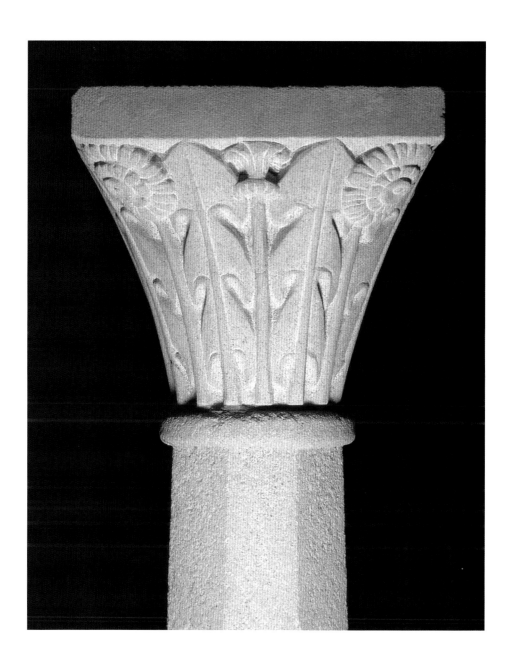

Dandelion

Connections back to your beginnings.

Remember dark times in the womb

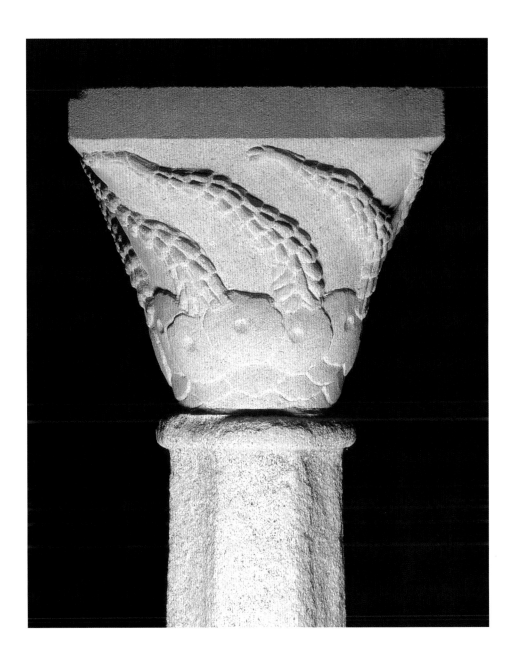

Navelwort

Where heartbeats lulled us all to sleep;
Life's rhythm-keeper soothed our soul.

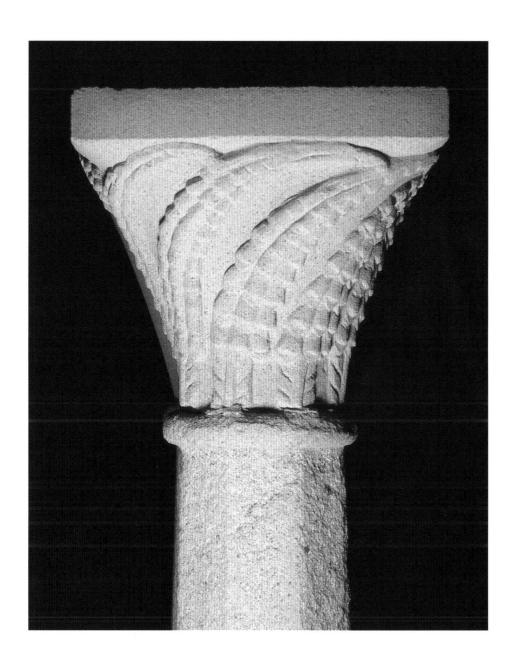

Foxglove

And feeding from the Earth's life-fluid
These flags fly high then quickly fade,

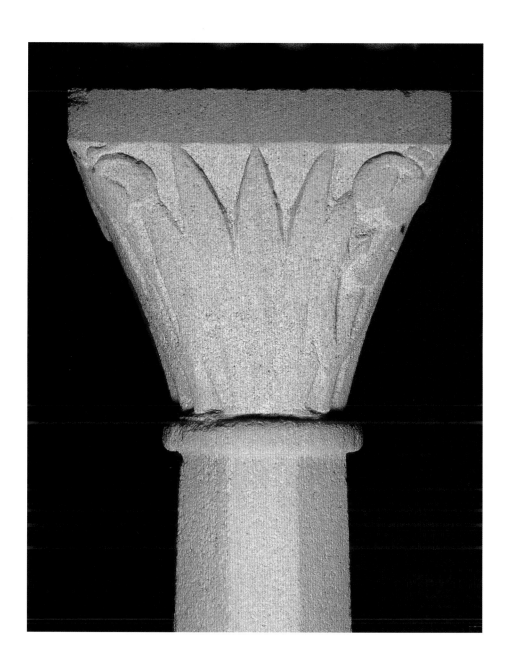

Iris

Like distant sounds of ringing bells;
Chimed harmonies blown in the air.

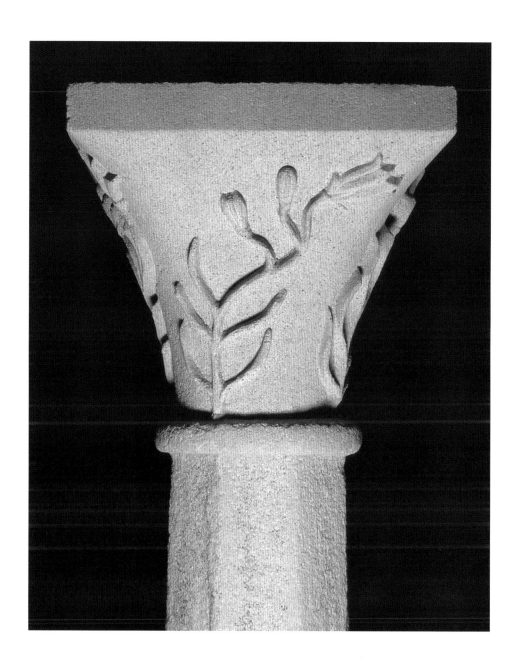

Harebell

Stand tall in torment and in pain
Surrounded by your dying fears.

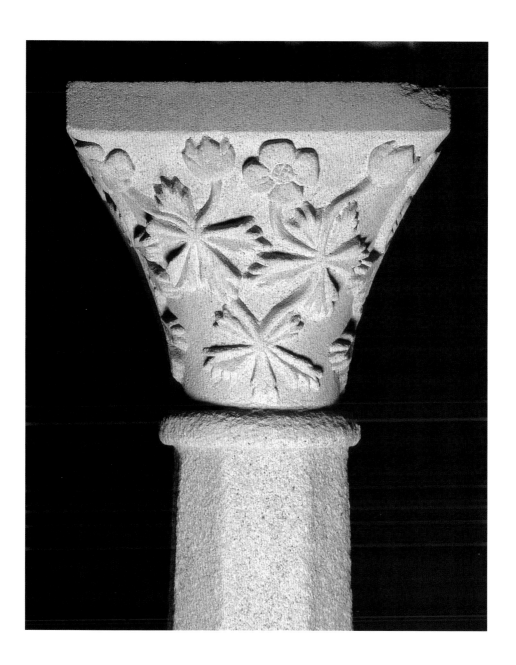

Tormentil

Once round your journey starts to end,
Where once it flowed it tries to ebb.

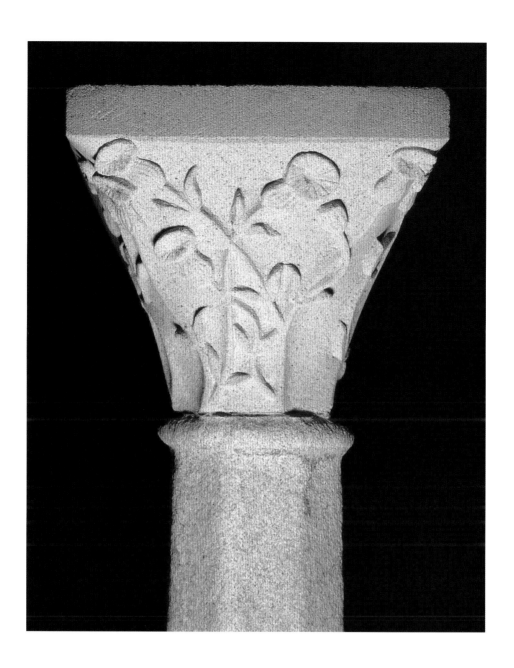

Sea Campion

But by the power of this Stone-breaker
We can turn the corner once again.

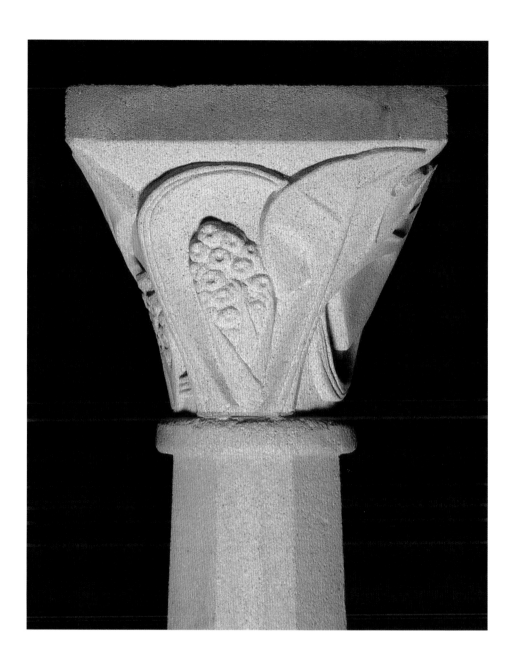

Saxifrage

Parable of the Mustard Seed

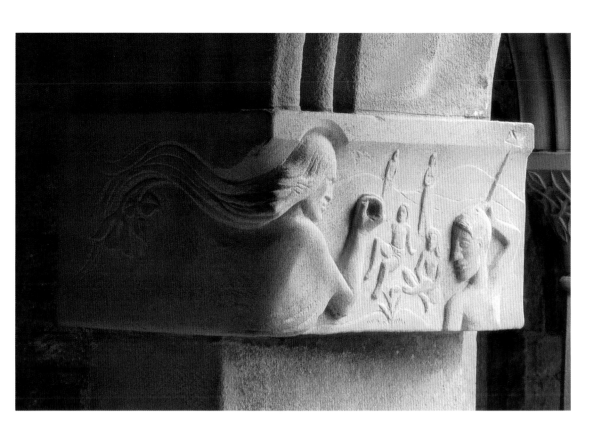

Appendix

The Cloisters Poem

East

Thorns Let the red crown, blood soaked, thread
Mark out this royal pathway straight ahead.

Oak Go, worship in the shade of these tall groves,
Most ancient hosts for all our thoughts,

Darnel Here, deep within, live poisoned growths,
That time turns black to harm us.

Narcissus And how our image is bright reflected,
So clearly, that we think we see it.

Cyclamen So circle, humbly, this endless pathway,
In eternal, constant, ringing motions:

Bulrushes And be saved from drowning rivers
That wash over your ambitions.

Vine Drink deep instead of finer wines;
Of life, and love, and happiness.

Wheat Eat too your daily risen staple:
For strength of body needs enriching.

Vetch Let differences and misunderstandings
Lead to laughter, smiles and joy.

Palm	Your outstretched hands in triumph raise A victorious cry of upright grace.
The Burning Bush	Warmed by the everlasting flame, that springs Alive; transcending all belief.
Olive	Pause: anoint your feet with reverence For carrying you on your way.
Fig	Of sensuality and prosperity; Be moved to feast on these.
Anemone	The windflower blows the soul's breath And beauty bears a white star in death.

South

Gannet	As Old Solan falls, with wings snap shut, To pierce the waves in search of life,
Osprey	Use your claws to cling to hope, And live your life close by the edge.
Snipe	Escape these green curtains, drawn in cover, Sound out your drums and beat in time.
Heron	Rise up and then glide gracefully down; Stand firm, head crowned. Above all else:
Dove	Embrace creation's central power of light, Whose peace shall beam beyond us.
Merlin and Swallow	Cast forth your Art, that all might see How simply you take on your fate.
Great Northern Diver	See how in one, so black and white, The rarest and the greatest meet.
Corncrake	Yet rarer still, our will to speak, And overcome the silences.
Tern	Look back along the sky's high edge, Where light abides, as this day ebbs.

West

Primrose	When evening comes, and autumn falls, The twilight world of sprites unfolds.
Medieval	Old mysteries now revealed as true, The legends of our elders' age
Medieval	Inspired creation of this space; Through which we pass in awe.
Dog Rose & Heather	Pressed close to rocks, to lie in rest, Gaze on points of simple beauty.
Bog Myrtle	In death; life's purpose understood. As fragrance from these leaves evokes
Christmas Rose	A time of darkness and new light: When hope is born to rise again.
Lily of the Valley	Scents so strong they carry you Away beyond your present place.
Spring Gentian	Thoughts from youth fill up your mind, With pure wonder at just knowing
Snowdrop	How spring unfolds, each year, to meet us, Rainbows bring the end of storms.
Birdsfoot Trefoil	Step lightly on these pads of gold; Threefold holders of delight.

Honeysuckle Draw on your stock of former lives;
 Raw essence of your own rebirth.

Butterwort Choose carefully the route you take,
 Avoid the traps that can deceive.

Warren Crocus But our in-spiral journey does not confuse;
 The goal is both the start and end.

Sundew No danger here of sticking fast
 Where others have before us failed.

North

Marguerite	Nightfall: time of dreams and passions, Full moon's eye stares into our soul.
Ivyleaf Toadflax	Now that each step is lit by stars Echoes of memories, held on to, fade
Thistle	But pricked, we do recall a time When those attacked were timely saved
Scottish Rose	To drink sweet liquor here distilled From fruits of one year's blazing sun.
Dandelion	Roar as you eat, and count the time Spent seeking; hoping soon to find
Navelwort	Connections back to your beginnings. Remember dark times in the womb
Foxglove	Where heartbeats lulled us all to sleep; Life's rhythm-keeper soothed our soul.
Iris	And feeding from the Earth's life-fluid These flags fly high then quickly fade,
Harebell	Like distant sounds of ringing bells; Chimed harmonies blown in the air.

Tormentil	Stand tall in torment and in pain Surrounded by your dying fears.
Sea Campion	Once round your journey starts to end, Where once it flowed it tries to ebb.
Saxifrage	But by the power of this Stone-breaker We can turn the corner once again.

Behind the Cloisters

EAST

– moving North to South

Plants of the Holy Land

1. Thorns

'Crown of Thorns' made from long branches of 'Christ thorn' or 'spiney burnet'. The thorn was a symbol of sin in biblical times.

Biblical references:
> Matthew 27: 28–29
> 'They stripped him and dressed him in a scarlet cloak; and plaiting a crown of thorns they placed it on his head, and a stick in his right hand.'
> Mark 15:17
> 'They dressed him in purple and, plaiting a crown of thorns, placed it on his head.'

I find it interesting that these two versions refer to Jesus being clothed in red or purple. These two colours have very different sacred meanings. The purple signifies the highest level of awareness (and of royalty) while red is the base colour of consciousness. It is interesting to speculate what each of the writers were trying to convey with this powerful image. Rainbows begin and end with these colours and if you mix them together you get brilliant white light. Maybe the writers were colluding with each other! It is also worth noting that the next capital is the oak. This plant provided the ancient Druids with their crown.

Chris Hall feels that it was not himself who carved this one. He has included a familiar Celtic symbol by using the eternal trinity knot in the centre of the capital. This gives us an excellent place to begin the journey.

2. Oak

The oak was a very common tree in ancient Europe and many of its names came to mean 'tree'. The English word 'tree' probably comes from an Indo-European word meaning 'oak'. Tree groves were used by Druids as sacred places and, along with the yew, the oak was one of the most revered of all trees. It is therefore fitting that it should be beside the biblical Thorns. Oak trees were also important in the Middle East as shade-giving plants.

Oaks are host to a huge variety of insects and fungi that depend entirely on the oak for life. Chris Hall has included an oak apple in the carving to reflect this. Oak trees also have the ability to decay their centres so that they may better defend themselves against storms.

Biblical references:

2 Samuel 18:9–10

'Some of David's men caught sight of Absalom; he was riding his mule and, as it passed beneath a large oak, his head was caught in its boughs; he was left in mid-air, while the mule went on from under him. One of the men who saw this told Joab, "I saw Absalom hanging from an oak." '

Further references:

Isaiah 2:13 Ezekiel 27:6

3. Darnel

In Latin the darnel is *nigella*, meaning the plant with black seeds. Darnel is also known as poison rye grass, tare and ivray. It is a plant that likes to grow in fields of grain, particularly wheat. It is very hard to distinguish from young wheat and this would have made it difficult to eradicate. If wheat contaminated with darnel is ground into flour, it is possible that someone eating the resulting bread could be poisoned.

In older translations of the Bible darnel is referred to as 'tares' while in later texts it is simply 'weeds'. See also **9. Vetch**.

Biblical reference:

Matthew 13:24–30

'Here is another parable he gave them: The kingdom of Heaven is like this. A man sowed his field with good seed; but while everyone was asleep his enemy came, sowed darnel among the wheat, and made off. When the corn sprouted and began to fill out, the darnel could be seen among it. The farmer's men went to their master and said, "Sir, was it not good seed that you sowed in your field? So where has the darnel come from?" "This is the enemy's doing," he replied. "Well then," they said, "and shall we go and gather the darnel?" "No," he answered; "in gathering it you might pull up the wheat at the same time. Let them both grow together till harvest; and at harvest time I will tell the reapers, Gather the darnel first, and tie it in bundles for burning; then collect the wheat into my barn." '

4. Narcissus

Narcissus was, in Greek myths, a young man who died for the love of his own reflected beauty; on his death he became this flower. The name comes from the Greek *narkissos* meaning daffodil which, in turn, comes from *narke* meaning numbness or narcotic. The narcissus often grows by pools and seems to bend over to catch a glimpse of itself. In the Bible it is often translated as 'rose'.

Biblical reference:
> The Song of Songs 2:1
> 'I am a rose of Sharon, a lily growing in the valley.'

5. Cyclamen

The name is from the Greek *kuklaminos*, from *kuklos* which means a ring, round or a circle. Although cyclamen does grow in the Holy Land I could find no particular biblical associations.

This carving was commissioned as a memorial for a young girl who died in her sleep. It was carved one Easter, when the girl's parents were on the island. When they came to see it completed they noticed that the number of flowers carved was the same as the age of their daughter; this happened without Chris Hall knowing her age.

6. Bulrushes

Biblical reference:
> Exodus 2:3
> 'Unable to conceal him any longer, she got a rush basket for him, made it watertight with pitch and tar, laid him in it, and placed it among the reeds by the bank of the Nile.'

This is the story of how Moses was found by the Pharaoh's daughter. It is thought that the bulrushes in this story may well have been papyrus reeds. Chris Hall feels that the style of this carving mirrors a gothic pointed arch.

7. Vine

The grape vine was a symbol of peace and prosperity. As vines grow they twist and spiral,

with all branches growing directly from the main stock. Traditionally, if a branch fails to grow, it is cut off and burnt. Vines are principally grown to provide grapes for wine-making. Wine was used by Jesus at the last supper along with bread made from the wheat of the next carving.

Jesus talked of the vine in five parables and described himself as the one 'true vine'; with all believers being the branches and with their roots in him.

Biblical references:
John 15:1–2
'I am the true vine, and my Father is the gardener. Any branch of mine that is barren he cuts away; and any fruiting branch he prunes clean, to make it the more fruitful still.'
John 15:5
'I am the vine; you are the branches. Anyone who dwells in me, as I dwell in him, bears much fruit; apart from me you can do nothing.'
Mark 14:23-25
'Then he took a cup, and having offered thanks to God he gave it to them; and they all drank from it. And he said to them, "This is my blood, the blood of the covenant, shed for many. Truly I tell you: never again shall I drink from the fruit of the vine until that day when I drink it new in the kingdom of God."'
Further references:
Numbers 13:20–24 Matthew 9:17; 20:1–6; 21:28–33 John 2:1–11

8. Wheat

One grain of wheat dies in the soil to give birth to many more grains as the plant grows; spiritual fruitfulness through self-denial. Ground into flour wheat makes bread, a staple food for thousands of years.

Wheat was used by the Hebrew priests to make the best bread for use in offerings, while barley was used for the peasants' bread, barley ripening earlier than wheat. Wheat was a symbol of God's goodness and provision.

Perhaps it was no accident that Jesus took bread made from wheat, rather than barley, and broke it at the last supper. The wheat gives us bread, for stability and strength, and wine gives us the spirit.

Biblical references:

Matthew 26:26

'During supper Jesus took bread, and having said the blessing he broke it and gave it to the disciples with the words: "Take this and eat; this is my body." '

Further references:

Exodus 9:31–32 Ezekiel 4:9 (A recipe for bread) John 12:24 Psalms 81:16

9. Vetch

This carving is a small mistake; it should have been darnel. Chris Hall was asked to carve tares, as in the parable, and so he carved this. In the parable only God could tell the difference between wheat and tares (good and evil) but here Chris says he could not even tell the difference between one tare and another! The vetch *vicia* is a member of the pea family and the variety *Vicia sativa* = tare = darnel; hence the confusion.

10. Palm

The date palm gets its name from the shape of its leaves which spread out like fingers on this branchless tree and from its fruit which looks like little fingers. The word 'date' comes from the Latin *dactylus*, meaning finger and 'palm' comes from *palma* meaning palm of the hand.

Palm branches were a symbol of victory, triumph and pre-eminence; they are often seen on Egyptian stone columns. The palm is now used as a national symbol in Israel for 'victory'.

Biblical references:

John 12:12–13

'The next day the great crowd of pilgrims who had come for the festival, hearing that Jesus was on the way to Jerusalem, went out to meet him with palm branches in their hands, shouting, "Hosanna! Blessed is he who comes in the name of the Lord! Blessed is the king of Israel!" '

Further references:

Psalms 92:12 Judges 4:5

11. The Burning Bush

This is one of Chris Hall's favourite capitals and the first one for which he felt real inspiration while carving; like a dream it came with great ease. The spirit of God in the centre of the intertwining suggests Celtic knotwork. Chris describes it as very alive, almost transcendental, art.

Biblical reference:
Exodus 3:1–2
'While tending the sheep of his father-in-law Jethro, priest of Midian, Moses led the flock along the west side of the wilderness and came to Horeb, the mountain of God. There an angel of the Lord appeared to him as a fire blazing out from a bush. Although the bush was on fire, it was not being burnt up.'

12. Olive

In ancient Greece a crown or wreath of wild olive was given to victors in sporting events. The olive branch was a symbol of peace. Olive trees are also important as a source of oil for cooking and lamps and as body oil for anointing, being symbolic of the Holy Spirit. The Garden of Gethsemane, scene of Jesus's betrayal, was an olive grove.

Biblical references:
Deuteronomy 24:20
'When you beat your olive trees, do not strip them afterwards; what is left is for the alien, the fatherless, and the widow.'
1 Kings 6:23
'In the inner shrine he carved two cherubim of wild olive wood, each ten cubits high.'

13. Fig

The fig is another symbol of peace as well as a herald of the summer. The wood of the sycamore fig is used for coffins in Egypt. The fig is also associated with sensuality: when cut open lengthways the flesh inside resembles the female genitalia.

Biblical references:

Matthew 24:32

'Learn a lesson from the fig tree. When its tender shoots appear and are breaking into leaf, you know that summer is near.'

Further references:

Amos 7:14 Luke 19:4

14. Anemone

In Greek mythology Adonis, the beautiful youth beloved of Aphrodite, was killed while boar hunting. The anemone grew up from the spilt blood of the dying Adonis.

The Hebrew word *na'aman* was changed in folk culture to the Greek word for the wind-flower: 'anemone'. In Latin *animus* means soul or the spiritual principle of human life, the rational soul. 'Anima' means the breath: the principle of animal life. The anemone is also known as 'The Lily of the Field' and wood anemone.

This was the first capital that Chris Hall carved and he included a representation of the *icthus*, fish, symbol in the overlapping stems of the flowers. When he had just finished, the Queen Mother was visiting the island and was presented to him by George MacLeod, founder of the Iona Community.

Biblical reference:

Matthew 6:28

'And why be anxious about clothes? Consider how the lilies grow in the fields; they do not work, they do not spin.'

SOUTH

– moving East to West

Birds of Iona

1. Gannet

The gannet used to be known as the 'Solan goose', from the old Norse *sula* meaning gannet and *ond* meaning duck.

Gannets are large sea birds with a wingspan of up to two metres. They are noted for their high-speed diving when they fold up like scissors and enter the water at over a hundred kilometres an hour.

2. Osprey

These very rare birds of prey were extinct altogether in Scotland until their reintroduction in 1955. Ospreys are summer visitors to the highlands of Scotland. They are unusual in their hunting technique in that they dive feet-first to catch fish. Chris Hall included the osprey because they were in the news at the time when he was carving. It is quite possible that ospreys were on Iona in the past although there are none here now.

Etymologically 'osprey' means bird of prey. There is, however, some confusion with the old French *osfraie*, meaning bone-breaker; from the habit of lammergeier, a large vulture, of dropping its prey to break its bones.

3. Snipe

This is a wader with a distinctive long bill that hides in the reeds and iris leaves of Iona. It has a zigzag flight if disturbed, producing a loud drumming sound by the beating of its outer tail feathers.

4. Heron

The heron is one of the largest birds to be seen on Iona, particularly in the quieter winter months. It will patiently stand in water waiting for a fish to swim by before spearing its prey with its long sharp beak.

5. Dove

This is the central capital of this side and reflects the life of Columba, 'Dove of the Church', who came to Iona in 563 AD. In Latin *columba* means dove, a well-known symbol of peace.

Chris Hall took the inspiration for this work from an 18th-century print of a dove circling round Mary. Just above the ring of light was *fiat* (literally 'so be it' or 'let it be done'). He has tried to create an image of the moment of divine power through the feeling of light spreading out from a central source.

The day this carving was finished there was a service of dedication at which Chris read the poem 'Peace' by Gerard Manley Hopkins.

6. Merlin and Swallow

In Latin, merlin is *falco columbarius* – interesting as this contains *columba*. In Arthurian legend Merlin was a magician but perhaps he was also a shaman or holy person; this may provide a link to Columba who was perhaps a shaman for his time.

The merlin flies low and fast to catch smaller birds that are its prey, such as the swallow. Two or more merlins will chase a swallow until it is exhausted. This work tries to show nature as it really is. Chris Hall had not seen a merlin on Iona until he saw one at Port Bhan in the year of this carving.

7. Great Northern Diver

Although this is the largest of the divers, its rarity can make it difficult to find. Chris Hall really enjoyed creating this carving inspired by the work of the great American illustrator John James Audubon.

8. Corncrake

The Latin name, *crex crex*, comes from the sound the calling male makes day and night. It is an extremely rare summer visitor to the outer islands of Britain and is not found on the mainland at all. Iona usually has around five calling males each year. They rely on the late cropping of silage fields for their habitat. Unfortunately modern farming techniques have contributed to their decline.

If you look at the actual carving, you will see a beetle that was carved by Willie Donachie, a biologist friend of Chris's, while on holiday on Iona.

Inspiration for this carving came from Tom Scott's description of the corncrake, 'unseen creaking among the ungathered harvest', in his epic poem 'The Tree, An Animal Fable'.

9. Tern

This summer visitor is also known as the 'sea swallow' because of its pointed wings and tail and similar flight pattern. It needs this agility to pick up food from the surface of the sea without hitting the waves.

WEST

– moving South to North

Plants of the British Isles

1. Primrose

The primrose is a fairy flower, light and delicate. This carving shows some interlaced patterning of Celtic art.

2. Medieval 1

This is one of the two remaining medieval carvings that inspired the creation of the new carvings. The subject is unclear but it may be narcissi; the bold style here is reflected in the work of Douglas Bissett on the north side.

3. Medieval 2

This second original carving is in a more flowing, lighter style similar to the work of Chris Hall. It shows some Celtic influence and could be of the open lotus leaf pattern or possibly oak leaves.

4. Dog Rose and Heather

When Chris Hall was looking for the inspiration for this carving he took a walk in the hills. Lying in the heather he noticed how closely the geometry of the rock and the heather matched; this was the moment of inspiration. The carved heather is now hugging this capital as it would hug a real rock. Dog rose is often to be found intertwined with heather for protection.

5. Bog Myrtle

This is a powerful fragrant herb that grows between Loch Staonaig and Columba's Bay on Iona, and is common on boggy heath-land. Chris Hall says this was a difficult subject because the plant is not as distinctive as many of the others. However it does have a certain formation in the way it grows which he has tried to depict here.

6. Christmas Rose

There is a wonderful mystery to this carving; more than Chris Hall had intended. This darkness reminds us of the darkest time of the year at midwinter when the day and night are in perfect balance.

7. Lily of the Valley

This simpler carving is influenced by the style of Douglas Bissett. Chris Hall describes almost being able to smell the scent coming out of the stone.

8. Spring Gentian

This is a return to the lighter carving style to reflect this most delicate of flowers.

9. Snowdrop

The tiny flower is given a gothic majesty by this carving. Chris Hall says this is a favourite of many people but that it was surprisingly easy to carve.

10. Birdsfoot Trefoil

Described by Chris Hall as his 'homage to modern art' this was drawn straight from the flower onto the stone and so looks rather abstract and 'stuck on'. Despite this appearance he now feels very happy with the result.

11. Honeysuckle

The honeysuckle grows new shoots from the old stock, as this carving shows. This introduces us to the idea of Celtic rebirth: building the new out of the old. Chris Hall regards this piece as his 'tour de force': a complex design that was difficult to execute.

12. Butterwort

This carving is reminiscent of the primrose but is thought by Chris Hall to be more successful.

13. Warren Crocus

Also known as 'sand crocus', this plant has leaves that tend to spiral in growth. The exaggerated form here is, again, borrowed from the Celtic tradition.

Spirals were a very potent pagan symbol and Chris Hall was pleased to be able to include one here. This is one of my favourite carvings.

14. Sundew

This carnivorous plant catches its prey on large sticky pads and the carving includes a couple of flies that landed in the wrong place!

NORTH

– moving West to East

Plants of Iona

1. Marguerite

The marguerite is also known as 'ox-eye daisy' or 'moon daisy' in Britain. In Gaelic it is *Neòinean Mòr*.

From the marguerite to the iris on this side were carved by Douglas Bissett. His style is far physically deeper and more emblematic than Chris Hall's. As the two carvers worked together they began to influence each other more, Chris Hall getting stronger and Douglas Bissett flowing more. Unfortunately Douglas Bissett died after working on only these eight capitals.

2. Ivyleaf Toadflax

In Gaelic, *Buabh-lìon Eidheannach*. This is a very common, tiny-flowered, plant on Iona and is given a bold treatment here.

3. Thistle

There are many different types of thistle found on Iona:

Welted Thistle	*Fothannan Baltach*
Spear Thistle	*Cluaran Deilgneach*
Marsh Thistle	*Cluaran Lèana*
Creeping Thistle	*Fothannan Achaidh*

The thistle here is a representation of the traditional symbol of Scotland rather than of any one specific plant.

It has been said that the thistle was adopted as the national symbol for Scotland following the defeat of an army advancing on a castle. Victory for the castle's inhabitants was assured due to the presence of a great many large thistles in the ditch surrounding the castle walls!

4. Scottish Rose

This is probably the burnet rose, *Rosa pimpinellifolia*. The Gaelic name for this is *Ròs Beag Bàn na h-Alba*: literally 'the little white rose of Scotland'.

Roses produce rose hips from which rose hip syrup is made; rose petals are also edible – although not very interesting!

5. Dandelion

In Gaelic these are *Beàrnan Brìde*, which makes me suspect a link to St Bride but I have not yet verified this.

Literally dandelion means 'Lion's Tooth' from the shape of its leaves. This is from the French *dent-de-lion*, a translation of the medieval Latin *dens leonis*. In France it is also known as 'piss-a-bed' and 'pissenlit' from the plant's diuretic properties.

There are many other names for this plant, introduced by the Romans as a salad plant, including 'clock', 'farmer's clocks', 'schoolboy's clock', 'tell-time' and 'time flower'. These come from the tradition of blowing away the seeds from the seed head to the chant of 'one o'clock, two o'clock, three o'clock...'.

6. Navelwort

Navelwort is also known as 'wall pennywort' and can be found growing in cracks in rocks and on damp walls (it used to be found among the walls of the Nunnery on Iona).

Its unusual green flowers are similar to those of the foxglove but much smaller. The leaves resemble the human navel, hence the name. This becomes more obvious in the Latin name, *Umbilicus rupestris*; the Gaelic name being *Leacan*.

7. Foxglove

Foxgloves would be poisonous if eaten in large enough quantities as they contain the very useful heart stimulant digitalin. In Gaelic they are *Lus nam Ban-sìdh* and in Latin *Digitalis purpurea*.

8. Iris

This is one of the most distinctive of all the plants of Iona, with its tall green spears of

leaves and large yellow three-petalled flowers in June. It is known locally as 'yellow flag iris'. In Gaelic it is *Sealasdair*. This is the last carving by Douglas Bissett and is, as yet, unfinished.

9. Harebell

These small blue flowers are also known as 'the Bluebell of Scotland', 'witches' thimbles' and in Gaelic *Am Flùran Cluigeanach*.

This a favourite flower of Chris Hall's as they seem so fragile blowing in the wind. Legend says that if you put your ear to the flower you will hear the fairy bells ringing.

10. Tormentil

A very common shrub with small yellow flowers. Chris Hall found the small flowers very difficult to carve and so he decided to make a feature of the leaves rather than the flowers.

In Latin tormentil is *Potentilla erecta* and in Gaelic it is *Cairt Làir*.

11. Sea Campion

This carving was inspired by an icon Chris saw in Iona Abbey at the time and is taken from the shape he saw of the chalice on a table amongst some figures.

The Gaelic name for sea campion is *Coirean na Mara* and its Latin name is *Silene uniflora*.

12. Saxifrage

The Latin name is *Saxifraga tridactylites* and the Gaelic is *Clach-bhrìseach na Machrach*. Etymologically the name means 'the stone-breaker', which makes it an ideal subject for a carving. In Latin *saxifraga* comes from *saxum* which means rock and *frag-*, the stem of *frangere*, which means to break. Saxifrage grows in crevices and gives the impression that it breaks the rock.

This was an exciting carving for Chris Hall; he was inspired by the phrase 'The overshadowing power of God'. When saxifrage grows, the heads of the flowers come first followed by the large leaves later on; these eventually cover the flowers completely.

References

All biblical quotations are taken from *The Revised English Bible* © Oxford University Press and Cambridge University Press 1989.

The Gaelic plant and flower names follow the list published in the 2nd edition of *Flowers of Iona* by Jean M. Millar (The New Iona Press, 1993).

'Unseen creaking among the ungathered harvest' is a line from Canto 39 of *The Tree* by Tom Scott (pg. 110, line 29), Chapman Publishing/Borderline Press, 1976. *The Tree* is an epic poem tracing the stage-by-stage development of animal evolution. Copies available £5.50 inc. p&p from Chapman, 4 Broughton Place, Edinburgh EH1 3RX.

The Iona Community

The Iona Community, founded in 1938 by the Revd George MacLeod, then a parish minister in Glasgow, is an ecumenical Christian community committed to seeking new ways of living the Gospel in today's world. Initially working to restore part of the medieval abbey on Iona, the Community today remains committed to 'rebuilding the common life' through working for social and political change, striving for the renewal of the church with an ecumenical emphasis, and exploring new, more inclusive approaches to worship, all based on an integrated understanding of spirituality.

The Community now has over 240 Members, about 1500 Associate Members and around 1500 Friends. The Members – women and men from many denominations and backgrounds (lay and ordained), living throughout Britain with a few overseas – are committed to a fivefold Rule of devotional discipline, sharing and accounting for use of time and money, regular meeting, and action for justice and peace.

At the Community's three residential centres – the Abbey and the MacLeod Centre on Iona, and Camas Adventure Camp on the Ross of Mull – guests are welcomed from March to October and over Christmas. Hospitality is provided for over 110 people, along with a unique opportunity, usually through week-long programmes, to extend horizons and forge relationships through sharing an experience of the common life in worship, work, discussion and relaxation. The Community's shop on Iona, just outside the Abbey grounds, carries an attractive range of books and craft goods.

The Community's administrative headquarters are in Glasgow, which also serves as a base for its work with young people, the Wild Goose Resource Group working in the field of worship, a bi-monthly magazine, *Coracle*, and a publishing house, Wild Goose Publications.

For information on the Iona Community contact:
The Iona Community, Pearce Institute, 840 Govan Road,
Glasgow G51 3UU, UK.
Phone: 0141 445 4561
e-mail: ionacomm@gla.iona.org.uk web: www.iona.org.uk

For enquiries about visiting Iona, please contact:
Iona Abbey, Isle of Iona, Argyll PA76 6SN, UK.
Phone: 01681 700404 e-mail: ionacomm@iona.org.uk

Also from Wild Goose Publications...

THE IONA COMMUNITY (Video)
Today's challenge, tomorrow's hope
Narrated by Sheena McDonald

In response to many requests from the UK and abroad, the Iona Community has produced a new video showing not only the natural beauty of the Isle of Iona but also the life and work of the Community itself. Some of the aspects featured are:

- The island of Iona
- Work and worship at Iona Abbey and the MacLeod Centre
- The Camas outdoor centre
- The Iona pilgrimage
- Archive footage of early rebuilding work and community life
- The Wild Goose Resource Group in action
- The Community's mainland work and base in Glasgow

Those unable to visit Iona Abbey and the MacLeod Centre to take part in the guest programme will find this video useful in understanding the essence of the Community's life and work, while for those who have made the journey it will be an enjoyable reminder of their experience.

UK edition (PAL format) ·1 901557 31 6 · £12.99
US edition (NTSC format) ·1 901557 58 8 · £12.99

CHASING THE WILD GOOSE
The story of the Iona Community
Ronald Ferguson

The history of the Iona Community including St Columba's founding of an influential Celtic Christian community on the Hebridean island of Iona in the sixth century; the work of George MacLeod whose inspiration placed Iona firmly on the Christian map once again in the twentieth century; and the current broad span of the Community with its concerns for spirituality, politics, peace and justice.

> *Ron Ferguson has carried it off against the odds! He has managed to make contemporary church history exciting, funny and inspiring. By bringing this story right up to date the Iona Community have reminded us why they will be a force to be reckoned with tomorrow every bit as much as yesterday.*
>
> Andrew McLellan, Minister, St Andrew's and St George's, Edinburgh

192pp ·1 901557 00 6 ·£8.99

THE IONA ABBEY WORSHIP BOOK
The Iona Community

Services and resources reflecting the Iona Community's commitment to the belief that worship is all that we are and all that we do, both inside and outside the church, with no division into the 'sacred' and the 'secular'. The material draws on many traditions, including the Celtic, and aims to help us to be fully present to God, who is fully present to us – in our neighbour, in the political and social activity of the world around us, and in the very centre and soul of our being.

Every year, thousands of visitors make their way to Iona and many are changed by their time on this small Hebridean island which has been a powerful spiritual centre over the centuries. The Iona Community does not believe that people are brought to Iona to be changed into 'religious' people but rather to be made more fully human. The common life of the Community – which includes its services – is directed to that end.

Previous editions of the Worship Book (formerly *The Iona Community Worship Book*) were used with enthusiasm by groups and congregations in many parts of the world. It is hoped that this new, extensively revised edition will provide similar inspiration.

Pbk · 272pp ·1 901557 50 2 · £9.99

EACH DAY AND EACH NIGHT
A weekly cycle of prayers from Iona in the Celtic tradition
J Philip Newell

A collection of morning and evening prayers for each day of the week drawn from and based on the 'songs and prayers of the Gaels' collected by Alexander Carmichael in the late nineteenth century. Philip Newell, a former Warden of Iona Abbey, has focused each day's theme on an area of concern of the Iona Community: justice and peace; healing; the goodness of Creation and care for the earth; commitment to Christ; communion of heaven and earth; welcome and hospitality. The elegance and pure simplicity of this book make it an ideal aid to daily prayer and contemplation.

Pbk · 96pp · 0 947988 53 X · £7.99